Vignettes Vignettes
gnettes Vignettes V
Vignettes Vignette
gnettes es
V
Vignette
gnettes Vignettes V
Vignettes Vignette
gnettes Vignettes V
Vignettes Vignette
gnettes Vignettes V
Vignettes Vignette

ALPHONSE MUCHA

AN AMERICAN COLLECTION

Don Kurtz

Collectors Press, Inc.
Portland, Oregon

Acknowledgements

Jos. Trinner Posters are from the Bob Haas Collection, Kansas City, Mo.

Thanks also to: Pamela Humes; Elizabeth MeLampy; Patricia Kurtz

Collection:
Don Kurtz

Photographer:
Ralph Adams

Editor:
Michael Goldberg & Gail Manchur

Design:
Hoover H.Y. Li

Published by: Collectors Press, Inc.
P.O. Box 230986, Portland, OR 97281

Printed in Singapore

First American Edition

10 9 8 7 6 5 4 3 2 1

ISBN: 1-888054-06-9

Alphonse Mucha

The art nouveau movement burst upon the world in the mid-1890s and, by the beginning of World War I, was just as quickly fading. But from these short, transitional years, a great body of work would survive. Ultimately, over half a century later, interest in the art form once loved by so many would re-emerge.

Art nouveau is not one style in itself. It grew into its own particular interpretation in whichever country it took root. An incredibly amazing movement for its time, it was the first art movement in ages to turn its back on prior styles and influences and seek to devise its own "look," in this case, one of decidedly organic and naturalistic forms. Art nouveau was particularly distinguished by a

determination to create an aesthetic in
harmony with the needs of its age. In
other words, it was the first style that
tried to come to terms with industry and
recognize the demands of the modern
world. Ultimately, in this attempt, the
style would fail. An "artist-driven" move-
ment, art nouveau could not accomplish
successfully the marriage of art and
industry, and soon became relegated to a
decorative or surface style.

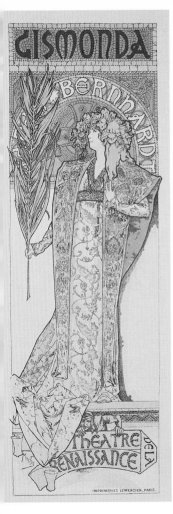

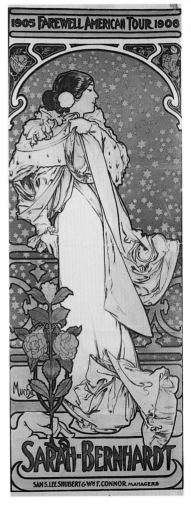

It was no coincidence that art nouveau style found its greatest expression in the field of commercial art and illustration. The advancements made in all facets of printing and reproduction in the 1890s led to a flourish of visual imagery never before seen in that specific art field. In less than twenty-five years, the poster had suddenly evolved into an art form in its own right. It would become the most readily-available form of art nouveau design for the general public. The poster

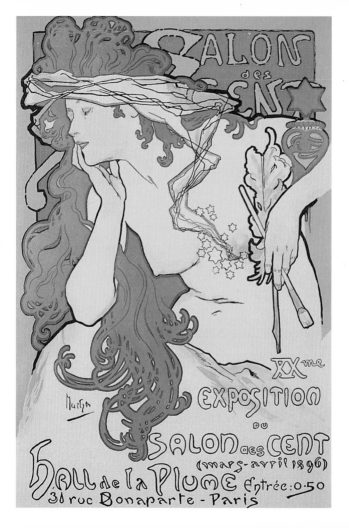

artists of the time employed idioms central
to art nouveau's persona: an incredibly rich
color palette running from the dramatic
to the lurid; a fondness for Eastern art,
particularly Japanese prints and their
intricate play between dark and light;
and a profoundly serious understanding
of ornament. At that time in Paris, there
developed a poster craze, and a great
many of the posters and panels of the
time would go directly to collectors and,
thereby, be preserved. It is for this reason

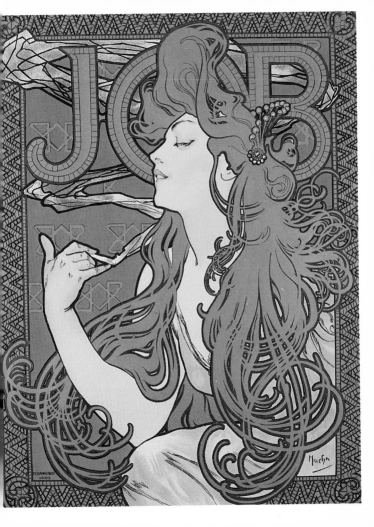

that so many of these works of art are found preserved for today's admirer and collector.

What were not so carefully preserved were other forms of commercial design: magazine cover art, book illustration, advertising art, menu designs, illustrated programs, and decorated calendars. For today's aficionado of art nouveau, this kind of material can be much more difficult to obtain in mint or even good condition than the more expensive posters and

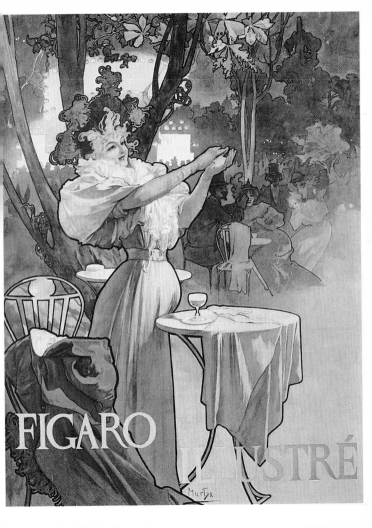

panels. Thus, this Vignette will present examples of these lesser-known works of art by the famous "poster artist" Alphonse Mucha.

When one thinks art nouveau, one also thinks of Alphonse Mucha. Although Mucha did not invent the form, it was through his work that the European exponent of the style found its most visible manifestation. When Mucha produced his first poster for Sarah Bernhardt's

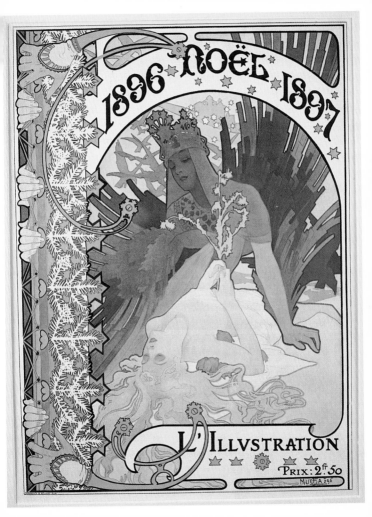

play, *Gismonda*, in 1895, he helped focus
the public's attention on the new art.
The art movement known as art nouveau
went by many style names at the time,
including nouille (noodle), whiplash,
youth, gaudi, metro, and, eventually,
Mucha style.

Alphonse Maria Mucha was born on
July 24, 1860, in the small Moravian town
of Ivancice, which was at that time a part
of the Austro-Hungarian Empire. His
father was a minor official with the local

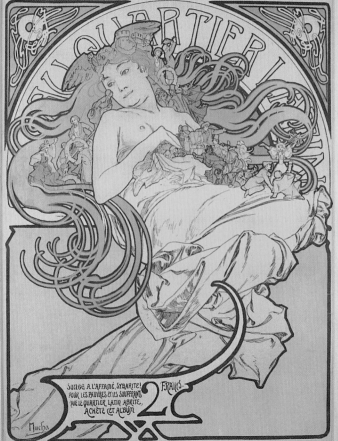

SONGE A L'AFFAMÉ, SYBARITE!
POUR LES PAUVRES ET LES SOUFFRANT
QUE LE QUARTIER LATIN ABRITE,
ACHÈTE CET ALBUM

FRANS.

Mucha

government. There was enough money,
but never an abundance. As was the
custom, Mucha was introduced to the
arts at an early age through the violin,
but it was his voice and choral music that
made it possible for him to continue his
high school education as a choir member
at the cathedral in Brno, capital of
Moravia. He briefly flirted with the idea
of attending a seminary and joining the
priesthood, but it came to nothing. A
stint as recording clerk for the court

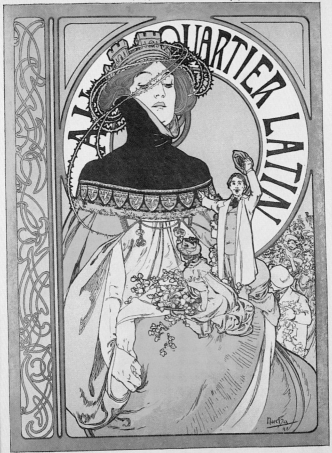

produced only boredom; and so, at the age
of nineteen, Mucha found himself with
nothing to do and with little direction.

From his youngest days he had
enjoyed drawing. He drew whenever the
opportunity presented itself and the idea
of becoming a painter lurked somewhere
in the back of his mind. But painting as a
profession was not looked upon favorably
by his family. He continued to be
involved in design and decoration in any
way he could through local art and

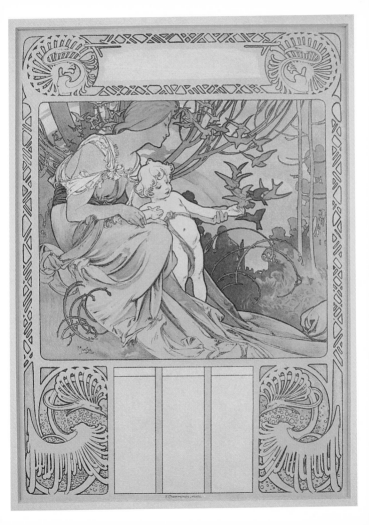

Chocolat Mexicain-Ages of Man-Adolescence Calendar

theater groups. In 1879 he successfully
answered an advertisement from a com-
pany which supplied theatrical scenery
in Vienna, which was looking for
painters. In the two years he spent with
the company he saw for the first time the
admiration and respect--and money--that
Vienna bestowed upon its artists. He
began to realize that a living could be
made as a painter. When the theater
burned down in 1881, Mucha was once
again out of work.

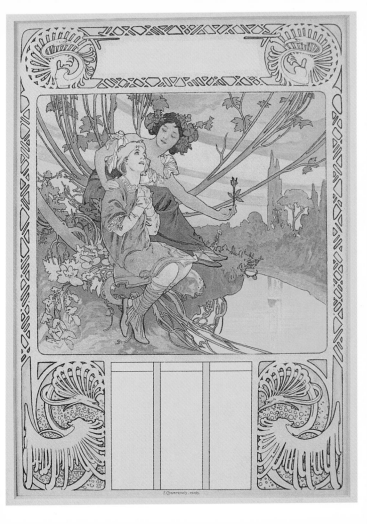

Chocolat Masson-Ages of Man-Adulthood Calendar

He took what little money he had, boarded a train with no particular destination in mind, and eventually found himself in the small town of Mikulov. It would not be the last time that fate would put him in the right place at the right time. He supported himself by selling small paintings, decorating theater scenery, and doing portrait work. It was in Mikulov that his work came to the attention of the area's largest landowner, Count Karl Khuen. Impressed with Mucha's work,

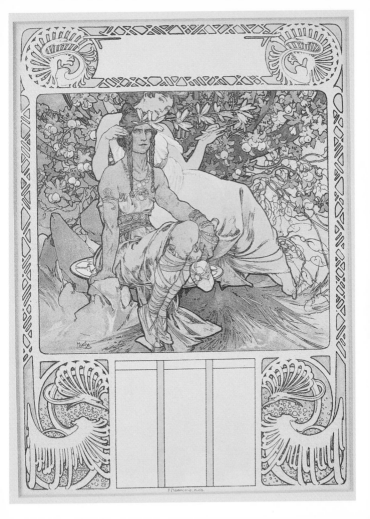

the count commissioned him to decorate
his castle at Emmahof with paintings and
murals. The count's brother, Egon, fol-
lowed with a commission for paintings at
his own castle. Count Egon fancied him-
self as a painter and he and Mucha spent
a great deal of time together discussing
their work and art in general.

Count Khuen was so pleased with
Mucha's work that in 1885 he decided to
sponsor him with tuition and financial
support at the Munich Academy. Two

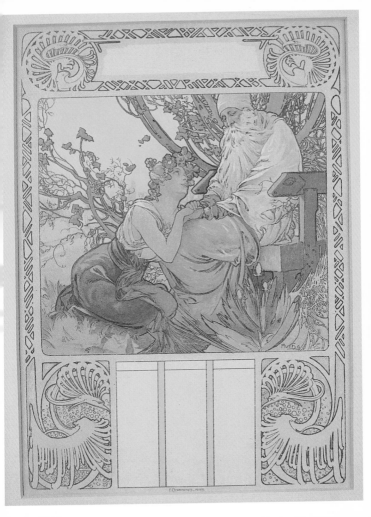

Letem Ceskym Svetem Book Cover
1898

years later Mucha convinced the count to move him to Paris and enter him first in the Academie Julian and later in the Academie Colarossi. The count's support of two hundred francs a month would last another two years, but by the time the money stopped Mucha had already begun to build his reputation as a competent, dependable, and hard-working illustrator.

During the period 1889-1894, Mucha earned his living by doing magazine illustrations for *Le Costume Au Theater, Le*

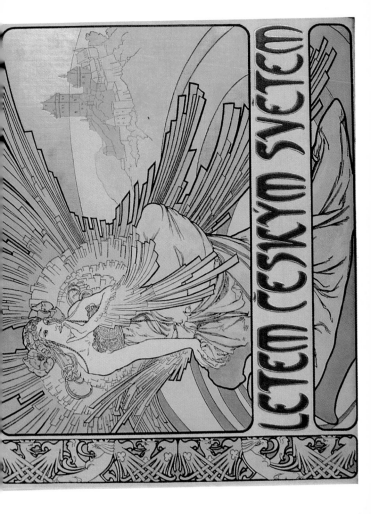

LETEM ČESKÝM SVĚTEM

Vie Popular, and *Le Petit Francais Illustre.*
He illustrated *Histoire DeDuex Enfants De
Londres* for Pascal Grousset, *Six Nouvelles*
for Charles Normand, and *Les Contes Des
Grand-Meres* for Xavier Marmier. He had
made a number of friends in the art com-
munity of Paris, and in his willingness to
help them with their own work, began
an informal school. More importantly, he
had gained the respect of many of Paris's
most important publishers and printers,
but as yet his name was not well-known

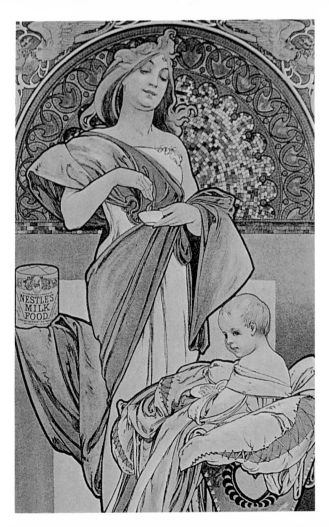

Les Menus Et Programmes Illustrés Book Cover

to the general public. And then fate stepped in again.

Late in December 1894, a friend of Mucha's in Paris was finishing a project for the printers Lemercier. The friend was leaving Paris for the Christmas holiday and asked if Mucha could finish some work on the proofs for him. Mucha agreed and spent Christmas day working at the printers. The following day de Brunoff, manager of Lemercier, received a call from Sarah Bernhardt, who said

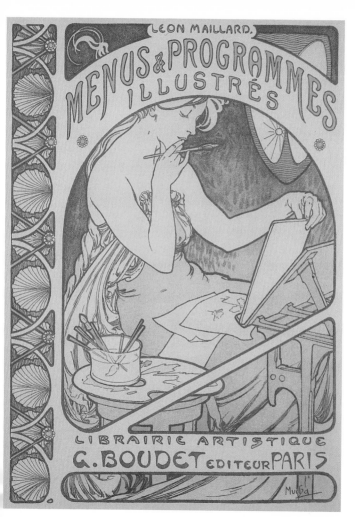

left

Moet & Chandon **Menu**
1899

right

Moet & Chandon **Menu**
1899

she needed a new poster for her current
play and wanted it ready for display by
January 1, less than a week away.
Everyone else was away for the holiday,
so de Brunoff turned to the available
Mucha, who had little experience in the
field, and asked if he would try his hand
at poster art. Mucha said he would like to
try, went to see the play that night, and
began to develop an idea for the poster.
When de Brunoff saw the first prints off
the press he found it too different, was

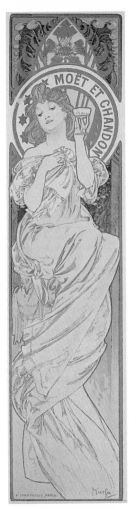

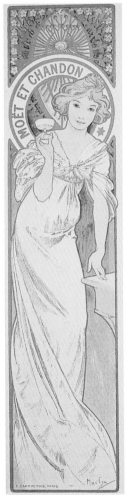

Paris World Magazine Cover
1901

disappointed and afraid to even let
Bernhardt see it. If time had not been a
factor he would never have shown the
work to her at all, but he had no choice.
To his amazement and relief, Bernhardt
loved it. The play was Sardou's *Gismonda*.

When the *Gismonda* poster appeared
on January 1, 1895, Mucha's career was
forever changed. Because it was so differ-
ent and so vivid, there was a great deal
of criticism from the art establishment,
but the public loved it. Mucha's pastels,

PARI'S WORLD

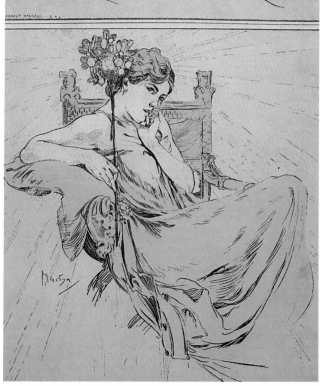

the intricate design work, even the very
shape of the poster (29 inches wide by
84 inches high, which made Bernhardt
almost life-size) was new and innovative.
Mucha's poster called for one to stop, to
move closer, and carefully examine the
piece.

No longer an unknown, the offers
and requests poured in to Mucha. Bernhardt
signed him to a six-year contract that
called not just for posters, but also for
costumes and set designs. The now-famous

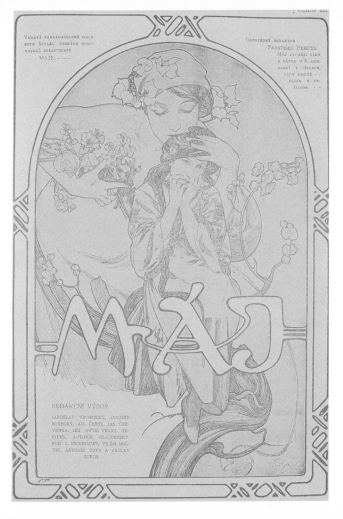

Bernhardt posters followed: *Amants* in 1895, *Lorenzaccio* and *La Dame Aux Camellias* in 1896, *La Samaritaine* in 1897, *Medee* in 1898, *Hamlet* and *La Tosca* in 1899.

Mucha's success in Paris led people world-wide to assume him a Frenchman. But Mucha was a Czech and an ardent nationalist. At the time of his birth, his home in Moravia was part of the Austro-Hungarian Empire, and for many Slavs, the character of the area had become too Germanized. It would

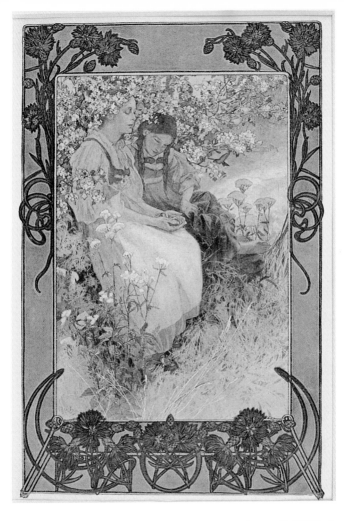

become Mucha's dream and mission to devote himself to the task of revitalizing and preserving the history, culture, and art of the Slavic peoples. To this end, and to fulfill his purpose as an artist, he saw in his future a series of great paintings depicting the "Slav Epic." He professed to feel that all his other work was no more than the means to this end. Mucha never lost the dream of his Slavic project. But, in spite of his popularity and his amazing output of work, the financial

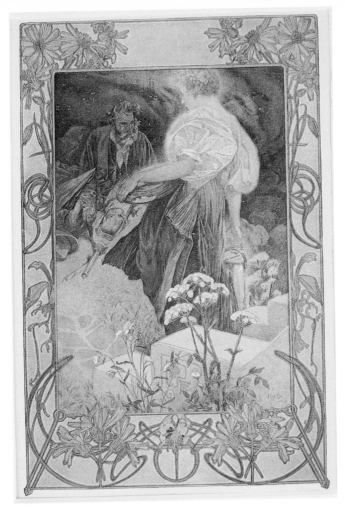

independence necessary to fulfill his
dream continued to elude him.

Mucha had become close to the
Rothchilds, and Baroness Rothchild
frequently told him how much he was
loved in America. Sarah Bernhardt told
him how much money there was to be
made in America. So, plans were made for
him to go to America.

Mucha arrived for the first time in
America in March 1904. The art nouveau

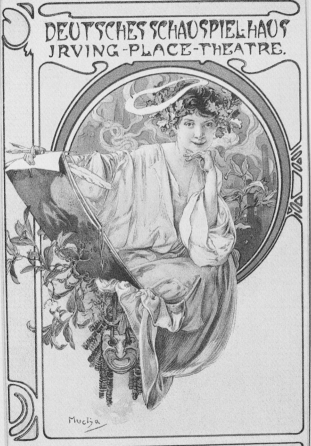

DEUTSCHES SCHAUSPIEL-HAUS
JRVING-PLACE-THEATRE.

D? MAURICE BAUMFELD---DIRECTOR

movement and his personal reputation
had preceded him. Names of art-nou-
veau-inspired designers and artists (like
Will Bradley and John Sloan, LaFarge
and Tiffany, Quezal and Van Briggle,
and the architect Louis Sullivan) were
already known to the American public.
The entire front page of the New York
Daily News color section for April 3, 1904,
was devoted to a Mucha piece depicting
Friendship. Mucha was embraced by
America and he responded by involving

MIDWINTER FICTION NUMBER

FEBRUARY 1907 PRICE 15 CENTS

METROPOLITAN
MAGAZINE

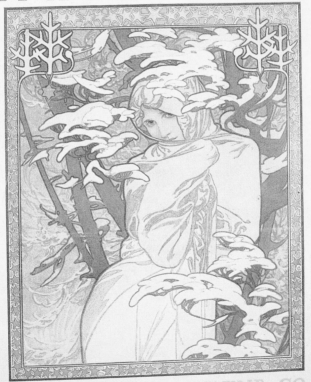

THE METROPOLITAN MAGAZINE CO

himself with every group and club with
an interest in art. He did artwork for
magazines, product advertising, and por-
trait work. But he was still unable to
accumulate enough of a bank account to
amount to anything. His art schools in
New York and Chicago did, however,
provide a steady income.

During much of the next decade he
would spend a great deal of time in
America, interrupted by short stays in
Paris, extended trips to Prague, and

Vol. XV
No. 57
CHRISTMAS NUMBER, 1907
Price, 3 Cents
Yearly Subst'n $3.00

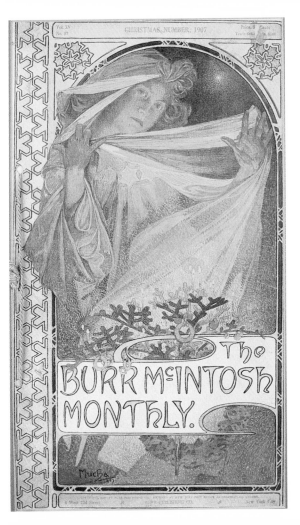

The
BURR McINTOSH
MONTHLY.

Mucha
1907

COPYRIGHT, 1907, IT ALSO HAS BEING CO. ENTERED AT NEW YORK POST OFFICE AS SECOND-CLASS MATTER
4 West 22d Street BURR PUBLISHING CO. New York City

tours of Slavic Europe. In America he
did covers for a Pittsburgh weekly, *The
Index* (1905), a full page *Easter Girl* for the
American-Journal Examiner (1906), and
Savon Mucha, a soap box and labels for
the Armour Co. of Chicago (1906). The
December 1906 issue of *Everybody's
Magazine* carried the beautifully illustrated *Beatitudes*. He did a cover design for
The Literary Digest, and the Christmas
1907 cover for the *Burr-McIntosh Monthly*.
There were posters for the actresses

The Literary Digest

Trade Reg. U. S. Pat. Off.

PUBLIC OPINION (New York) combined with THE LITERARY DIGEST

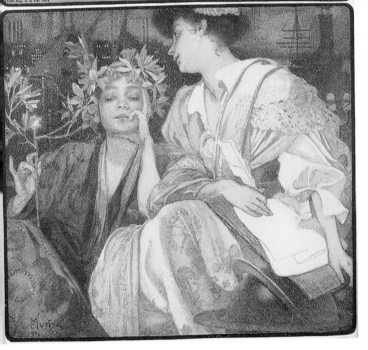

Maude Adams and Leslie Carter, and two posters for Chicago's Joseph Triner and his American Elixir of Bitter Wine. In 1908 he completed the murals and decorations for the German Theater in New York. He designed covers for *Hearst's International Magazine*; eight straight months, from December 1921 through July 1922, featuring "covers by Mucha."

Back in 1903 a young Czech girl, visiting Paris and wishing to be a painter, arranged through a relative to meet with

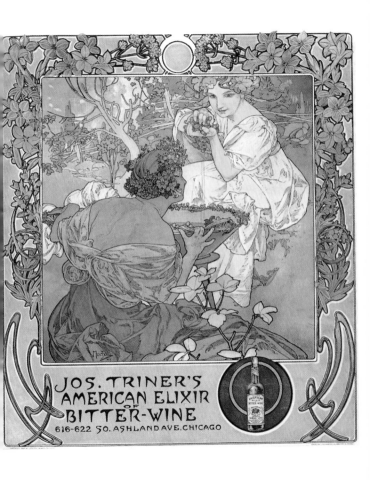

JOS. TRINER'S
AMERICAN ELIXIR
OF
BITTER-WINE
616-622 SO. ASHLAND AVE. CHICAGO

Jos. Triner's Bitter Wine Poster

Mucha to see if the famous artist and teacher would help her with her work. Three years later, the twenty-one-year-old Maruska Chytilova would marry Mucha in a grand Prague wedding. Their daughter, Jaroslava, was born in 1909, and a son, Jiri, in 1915.

Mucha met Charles R. Crane in New York in 1904 and over the next few years they became close friends. Crane was an American self-made millionaire

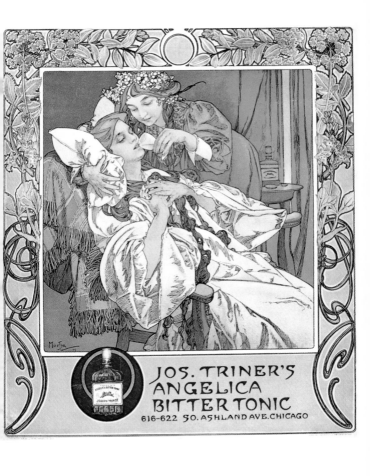

JOS. TRINER'S
ANGELICA
BITTER TONIC
616-622 SO. ASHLAND AVE. CHICAGO

who had a great interest in Eastern
European politics and culture. He had
traveled extensively and in Prague had
met T.G. Masaryk, who would become
the future Czechoslovakia's first presi-
dent. Crane's son, Charles, would
become the U.S. Ambassador to
Czechoslovakia and his daughter,
Frances, would eventually marry
President Masaryk's son, Jan. The
mutual interests of Mucha and Crane,
and their love of the Slavic peoples,

HEARST'S

INTERNATIONAL

For
January
35 Cents

Mucha

would finally bring Mucha closer to his
dream of revitalizing and honoring Czech
history and art. When Crane's daughter
Josephine married, he built her a house
designed by architect Louis Sullivan, and
asked Mucha to do Josephine's portrait,
using her to represent the symbolic fig-
ure of Slavia. The image has been used
often to represent Slavia with no mention
of the model. The image was later used
in 1918 on the then-new Czechoslovakian
100 Crown note.

Finally, in 1909, Crane told Mucha that he was ready to subsidize the Slav Epic. The first check of $7,500 gave Mucha the financial independence he had sought for so long. The following year Mucha found in the Bohemian castle of Count Jerome Mannsfeld a space with the correct light and area for the large paintings. Mucha and his family would spend most of the next two decades there.

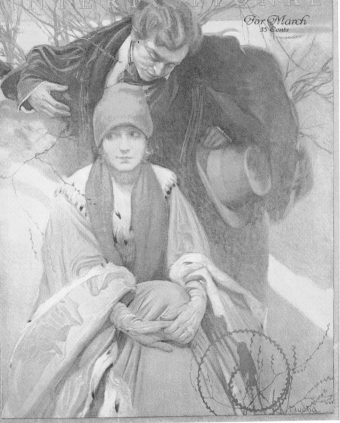

HEARST'S
INTERNATIONAL

For March
35 Cents

The first of twenty canvasses were completed in 1919 and shown in the United States over the following two years, first in Chicago and then in New York. The American audience loved the paintings and enough commissions followed to keep Mucha in the United States until 1921. When he returned to Europe in the spring of that year, Mucha would be leaving America for the last time.

HEARST'S

INTERNATIONAL

for April
35 Cents

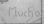

The Slav Epic Exhibition Poster
1928

The Slav Epic, his life-long dream, was completed in 1928 and presented to the city of Prague. Sadly, Mucha lived just long enough to see German armies march into his beloved Czechoslovakia at the beginning of World War II. Alphonse Mucha died July 14, 1939, his exquisitely-ornamented Slavic beauties forgotten in a world stirring with modernism and surrealism, abstract art and art deco.

Vignettes *Vignettes* *Vignet*

Vignettes *Vignettes*

es *Vignettes* *Vignet*

Vignettes *Vignettes*

es *Vignettes* *Vignet*

Vignettes *Vignettes*

es *Vignettes* *Vignet*

Vignettes *Vignettes*

es *Vignettes* *Vignet*

Vignettes *Vignettes*

es *Vignettes* *Vignet*